TAMWORTH

THROUGH TIME

Anthony Poulton-Smith

AMBERLEY PUBLISHING

Acknowledgements

Simon Hayward: p. 9 top, p. 10 top, p. 11 top, p. 12 top, p. 13 top, p. 78 top; Janet Willdig: p. 14 top, p. 15 top, p. 16 top, p. 17 top, p. 18 top, p. 19 top, p. 20 top, p. 21 top, p. 22 top, p. 23 top, p. 27 top, p. 30 top, p. 31 top; Terence O'Brien: p. 24 top, p. 25 top; Ankerside Shopping Centre: p. 26 top; Michelle Fawcett: p. 28 top, p. 29 top; Martyn Hearson: p. 32 top; www.tmcphotographs.co.uk: p. 33 top; Shuttington & Alvecote Parish Council: p. 34 top, p. 35 top; Mark Hastilow: p. 36 top; Robert Mansell: p. 43 top, p. 44 top, p. 45 top, p. 46 top, p. 47 top, p. 48 top, p. 49 top, p. 50 top, p. 51 top, p. 52 top; Chris Gibson prints of old Tamworth available at www.eventsindigital.com: p. 53 top, p. 54 top, p. 55 top; Backmanmal, Flickr.com: p. 65 top; Drayton Manor Park: p. 66 top, p. 67 top, p. 68 top, p. 69 top; tamworthtalks.co.uk: p. 70 top, p. 71 top, p. 72 top, p. 73 top, p. 74 top, p. 79 top, p. 80 top, p. 81 top, p. 82 top, p. 83 top, p. 84 top, p. 85 top, p. 86 top, p. 87 top, p. 88 top, p. 89 top, p. 90 top, p. 91 top, p. 92 top, p. 93 top, p. 94 top, p. 95 top, p. 96 top; Wikicommons: p. 75 top, p. 76 top.

First published 2013

Amberley Publishing
The Hill, Stroud
Gloucestershire, GL5 4EP

www.amberley-books.com

Copyright © Anthony Poulton-Smith, 2013

The right of Anthony Poulton-Smith
to be identified as the Author of this work
has been asserted in accordance with the
Copyrights, Designs and Patents Act 1988.

ISBN 978 1 4456 0946 1

British Library Cataloguing in Publication Data.
A catalogue record for this book is available from the British Library.

Typeset in 9.5pt on 12pt Celeste.
Typesetting by Amberley Publishing.
Printed in the UK.

Introduction

Rightly proclaiming itself the ancient capital of the Kingdom of Mercia, Tamworth has always been among the most important settlements in Staffordshire. While the town is officially of Saxon origin, ample archaeological evidence has been found of a much earlier settlement here.

The Celts were certainly here and not just passing through. Workers on the canal found an object during construction work. It was some years before this was recognised as the Tamworth Torc, a bracelet of twisted gold strands of exquisite craftsmanship and great value. In the town centre, Roman artefacts have been uncovered; no surprise considering that the Roman-built Watling Street, one of the great trunk roads of modern and historical times, skirts the southern edge of the town.

When the Romans left, the Saxons arrived. Many Mercian kings would have stayed at the palace in Tamworth, thought to have been located near the site of the present St Editha's church, including Penda, Wulfhere, Aethelred, Aethelbald, and the most famous of all, Offa. As yet, no one has identified a sure link between the fabulous Staffordshire Hoard, found just a few miles away, and Tamworth, but this can only be a matter of time.

The castle stands atop a mound, overlooking the confluence of the River Tame and the River Anker. It was the former that gave Tamworth its name, describing 'the enclosure on the River Tame'. Visitors to the castle museum will discover later royal visitors, including Henry II, Edward III, James I and the young King Charles I – long before he lost his head following the Civil War, of course. Around this time the Moat House was built. Home to some of Tamworth's wealthiest families for years, in recent times the castle has offered meals to hungry Tammies, including a few years as a Berni Inn.

Viewed from the top of the castle, the most obvious feature of the town is the parish church of St Editha. One of the largest churches in the Midlands, it is also one of the oldest. Records of its early history are sketchy but it is thought to have been built by Robert de Marmion, a Norman lord of Tamworth Castle. The tower boasts

a double spiral staircase. The two intertwine, making it possible for one group to ascend while others descend the other staircase.

Thomas Guy is a best known for the London hospital named after him. He also organised the building of Tamworth's almshouses and the town hall. Outside the town hall stands a statue of another of the town's most famous sons, Sir Robert Peel. His political career saw the introduction of an early constabulary, which led to the formation of a police force. He also gave the first political manifesto, as he listed his election promises when addressing a crowd from a window of the town hall.

The north and west of Tamworth are the oldest parts, while the south and particularly the east have seen many changes within living memory. The area that is now the Glascote and Amington housing estates was once mined for coal. With the seams worked out, these areas were developed and welcomed families from Birmingham on an overspill scheme.

Tamworth is famously associated with the three-wheeled Reliant Robin car. These cars were produced in the Two Gates factory for some sixty-five years until the company moved out of the town. Today a new housing estate occupies this site, the streets named after another famous Tammie. Colin Grazier was born in Tamworth and married days before he went to sea. A memorial in the town square to Grazier and two other men records how they drowned while diving to retrieve code books from a sinking U-boat. The documents proved invaluable when breaking the Enigma code at Bletchley Park.

Within these pages, the reader will see how parts of the town have changed over the years. While some are unrecognisable, others retain their appearances of even more than a century ago. Not only places but people at work and at play tell the story of Tamworth in the 200 old and new photographs that follow.

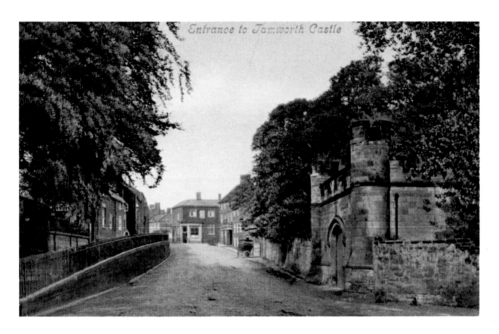

Holloway

Looking up Holloway, once the only route into Tamworth from the south. It earned its name because it was quite literally hollowed out and eroded by the passage of wheels, hooves and feet.

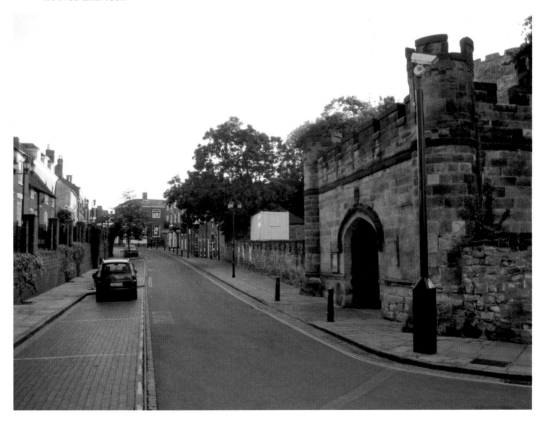

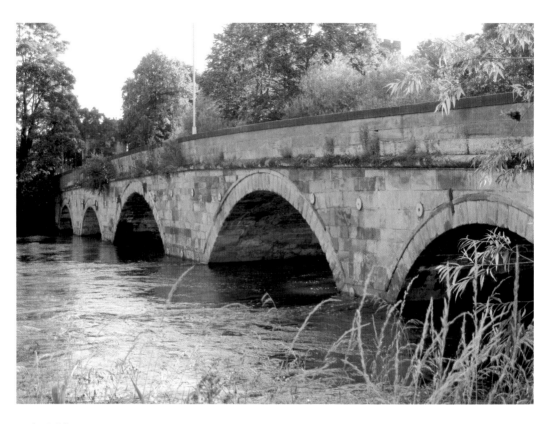

Lady Bridge

Below Holloway is Lady Bridge, where traffic is banned today. An old by-law still bans the washing of tripe in the river here.

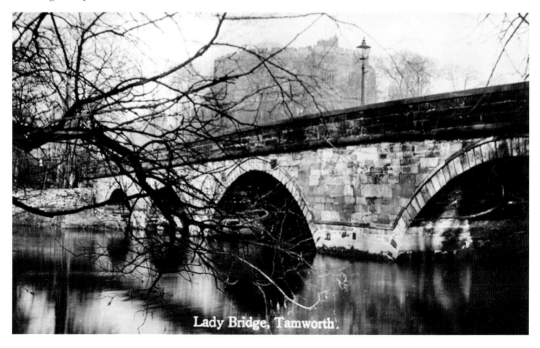

Lady Bridge, Tamworth.

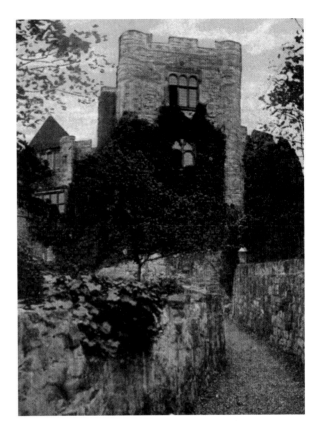

Tamworth Castle
Tamworth has had its castle for more than a thousand years. These images are separated by around a century; aside from the removal of the vegetation from the walls, very little has changed.

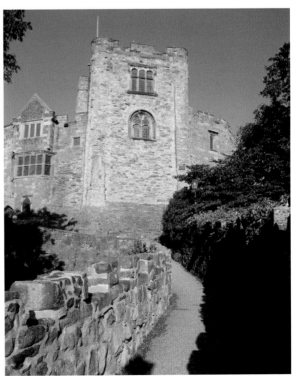

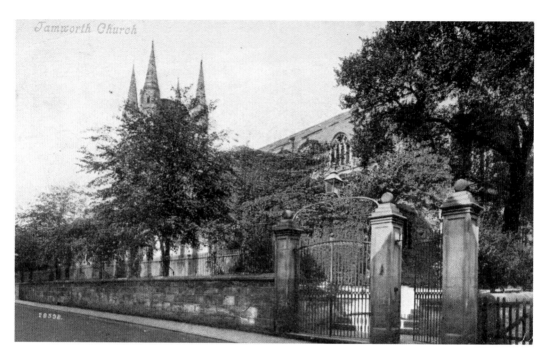

St Editha's Church

The church of St Editha is a Grade II listed building. Most of what we see is fourteenth and fifteenth century, with nineteenth-century additions. Our two images show nothing added but walls, gates and greenery taken away.

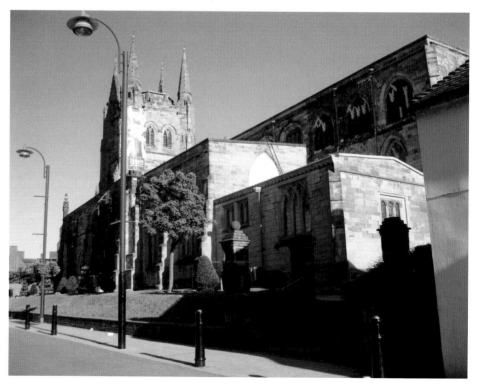

Castle Pleasure Grounds

The Hayward and Mills families enjoy a day out in the castle pleasure grounds in 1966. The Colditz flats can be seen in the background. The young man with the glasses in the foreground will be remembered by Tamworth Football Club supporters as Paul Hayward, who represented the club in the 1980s. The modern pleasure grounds include this twenty-first-century adventure playground (*inset*).

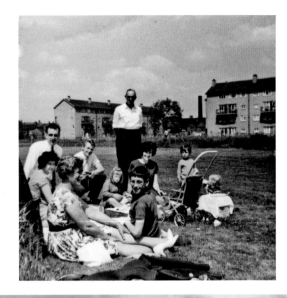

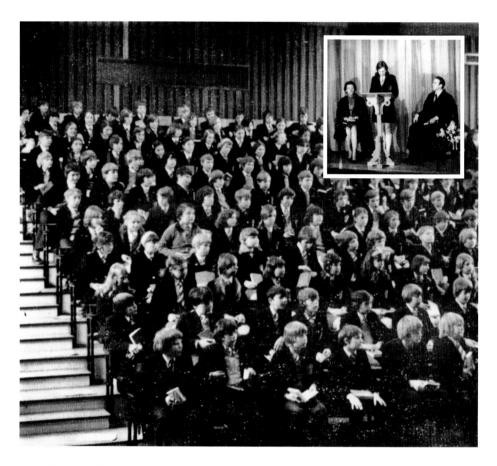

Woodhouse School, 1974

The traditional morning service is being held in the theatre at Woodhouse School, Amington, in 1974. The school was demolished in 2011 and the area landscaped. The present version opened in 2011 and is now known as Landau Forte Academy.

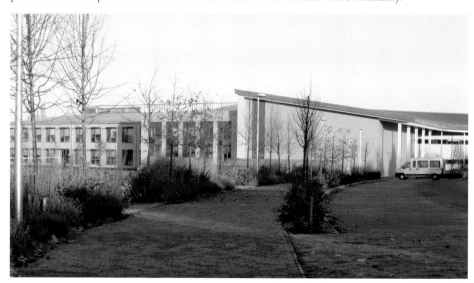

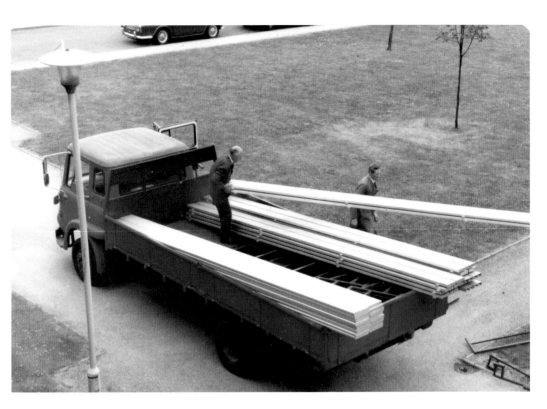

Woodhouse School, 1980

A delivery arrives at Woodhouse School, Amington, in 1980. This image was taken from the window of the school library. Below we see the entrance to the present building.

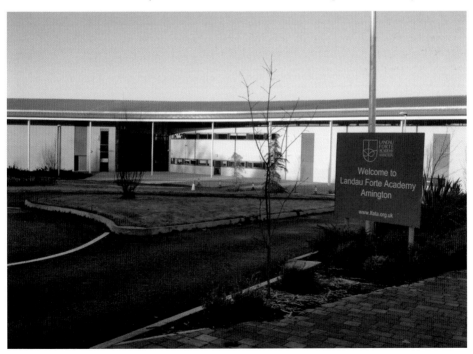

Woodhouse Lane

Woodhouse Lane, Amington, in 1978. The huge Amington estate was under construction behind the cameraman and would eventually extend to the right of this image. Many of the houses are still recognisable today.

Amington Estate

Building work continues in 1980, in the photograph above. The caretaker's house is to the right, the 1st Amington Scout Group's bus is in the centre, and clearly a great number of pupils came to school by bicycle. Below, the same view is seen more recently, shortly after the old building had been demolished and the area landscaped.

Market Street

Market Street in 1977, as building work began on the Ankerside Shopping Centre. As the name suggests, it has always been a busy shopping street.

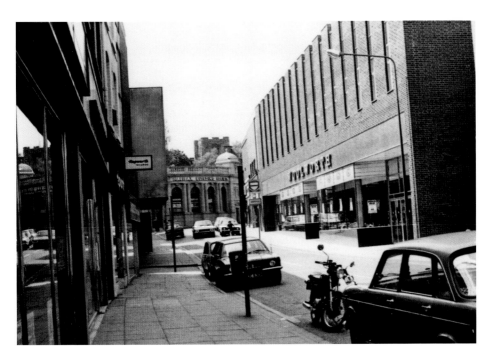

George Street
Woolworths in George Street in 1977, some years before the area was pedestrianised. Halifax Building Society can be seen in the background of both images.

Market Street

Market Street is seen above in 1977, as building work progressed. Below, the same view today; little has changed.

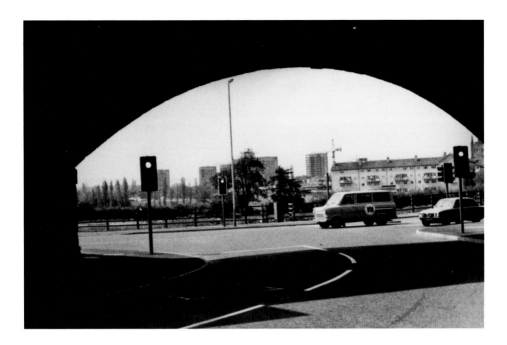

Bolebridge
Bolebridge is seen through the arches in the days before the controversial 'magic roundabout' known as the 'Egg' was constructed. In 2005 it was voted the fourth worst roundabout in Britain.

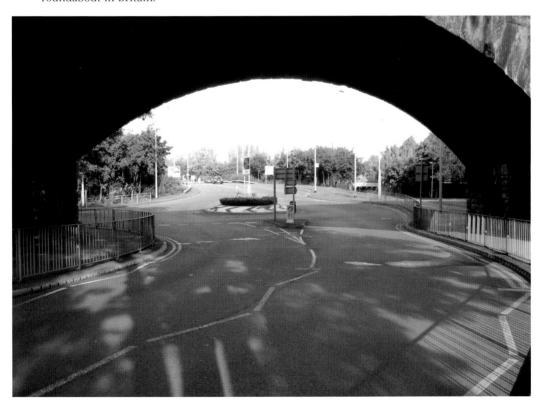

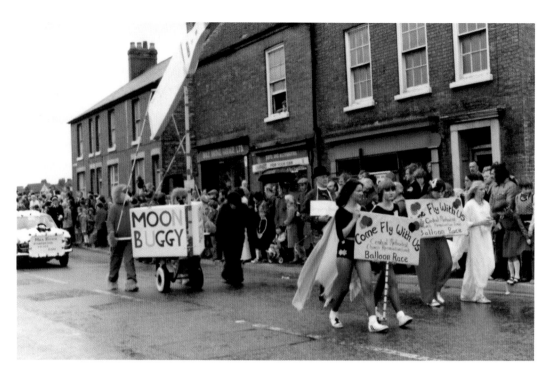

Tamworth Carnival, 1978
Tamworth Carnival takes place along Bolebridge Street on a damp day in 1978. The first carnival took place in 1931.

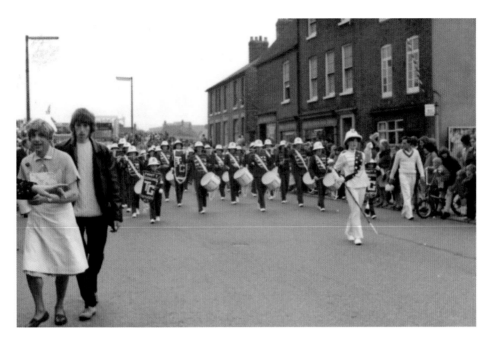

Tamworth Carnival, 1972
Six years earlier than the previous image, Tamworth Carnival marches along Bolebridge Street in a more orderly fashion. This annual event always has a good turnout.

Bolebridge Street
Bolebridge Street in 1977. The best indication of the location is the church tower in the distance. Much has changed in the intervening years, as this modern view of Bolebridge Street shows.

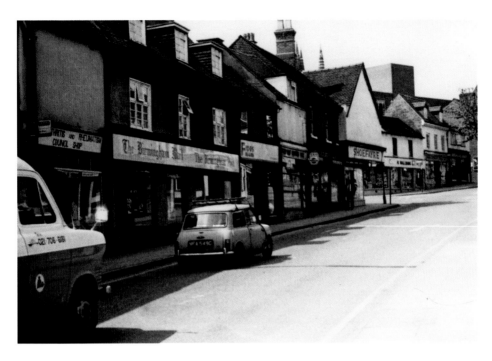

Bolebridge Street, Late 1970s
A more recognisable part Bolebridge Street is pictured above in the late 1970s, with Colehill in the distance.

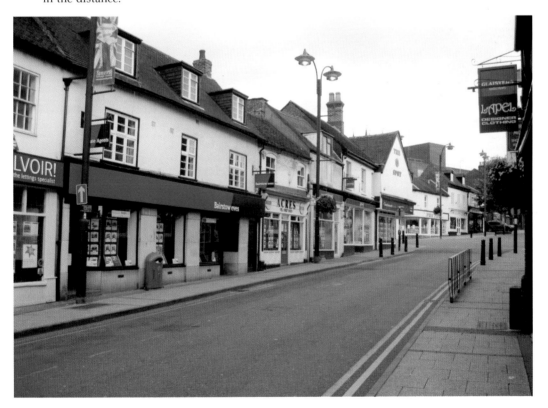

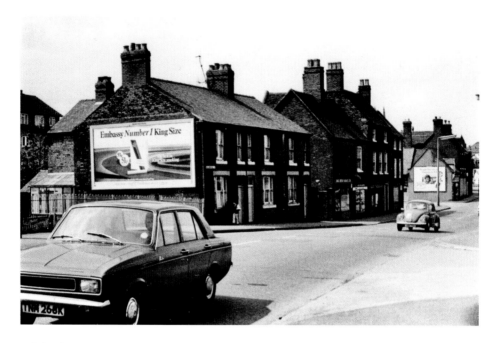

Bolebridge Street

Bolebridge Street lies at the heart of Tamworth and epitomises the wholesale changes that the town has undergone, particularly in the last forty years in the last forty years.

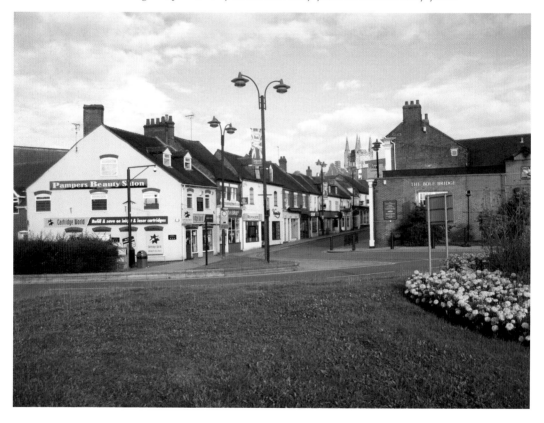

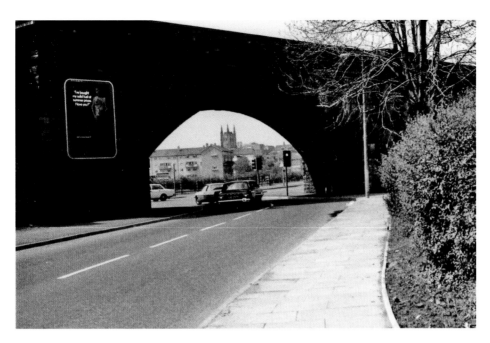

The Viaduct

The southernmost of the viaduct arches takes the railway on to that part of Tamworth Station correctly called Tamworth Higher Level. The current railway station was built in 1961.

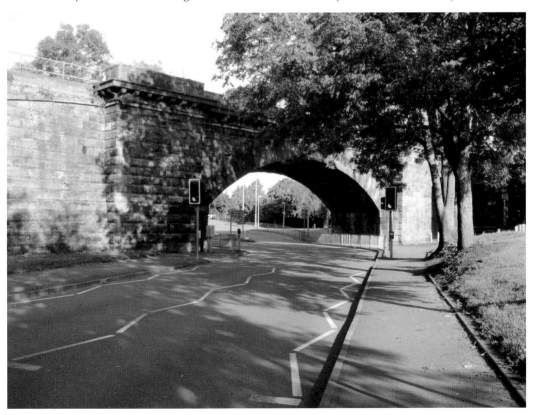

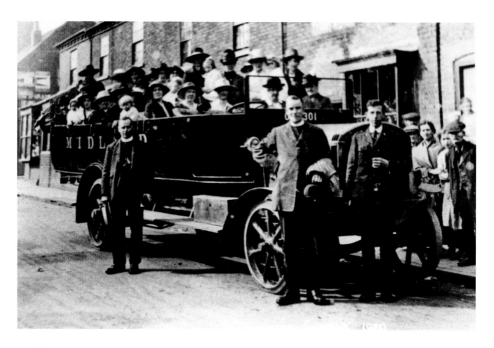

Hockley

A St Peter's church mothers' meeting outing in 1920 is seen above, and below is a modern view of their departure point along the main thoroughfare through Hockley.

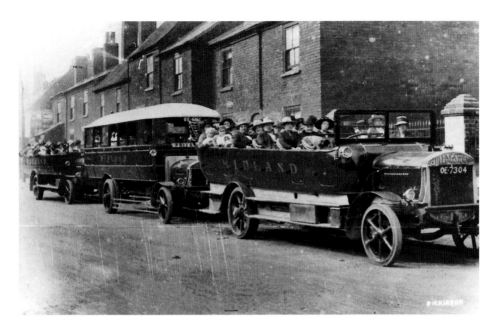

The Prince of Wales

While the mothers' meeting had its outing, doubtless some fathers popped into the nearby Prince of Wales, also on the Hockley Road, for refreshment. The pub's name highlights Tamworth's many royal connections.

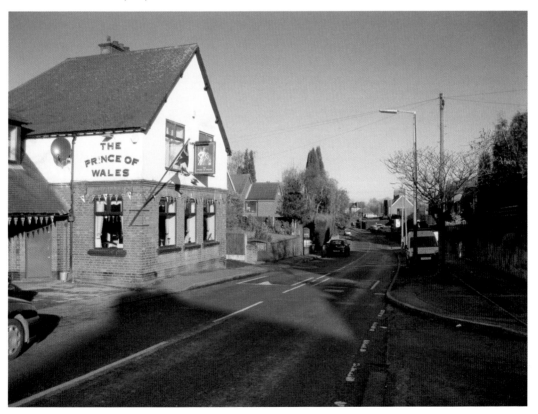

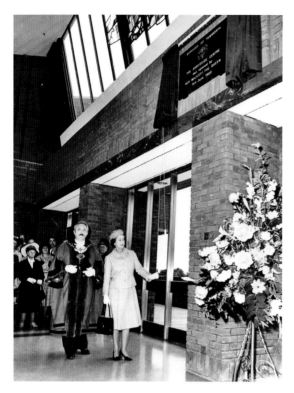

The Queen's Visit
On 6 June 1980, Her Majesty Queen Elizabeth II officially opened the Ankerside Shopping Centre. The plaque commemorates the event.

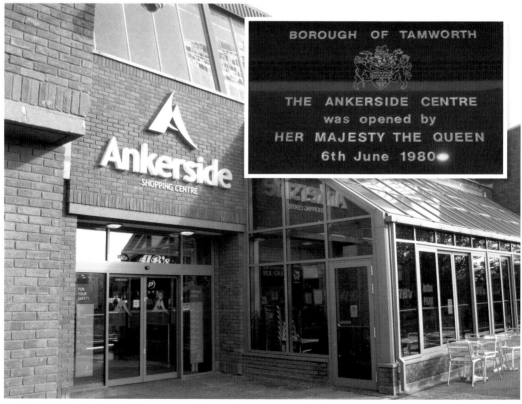

BOROUGH OF TAMWORTH

THE ANKERSIDE CENTRE
was opened by
HER MAJESTY THE QUEEN
6th June 1980

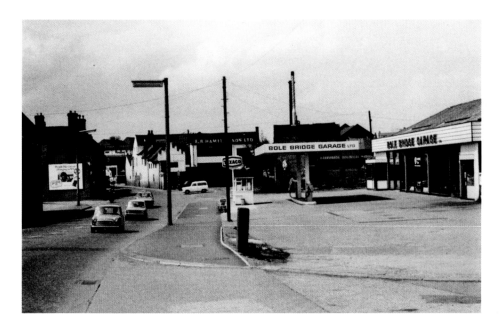

Bolebridge Garage

The old Bolebridge Garage survived the development of the 'Egg', but time took its toll. The site is now occupied by the Travelodge and a Lidl supermarket, which opened on 28 September 2012.

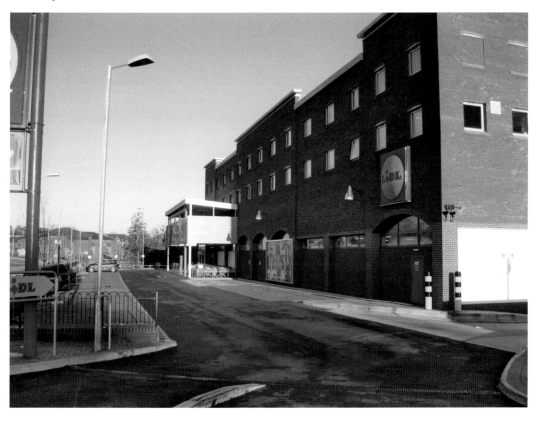

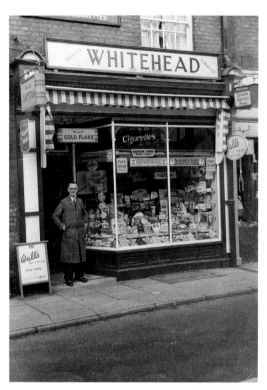

Whitehead's Sweets
Whitehead's sweet and tobacco store at no. 3 Silver Street in 1955. The only odd number in Silver Street today is no. 1; the others were demolished to make way for high-rise flats, just visible through the trees in the modern photograph below.

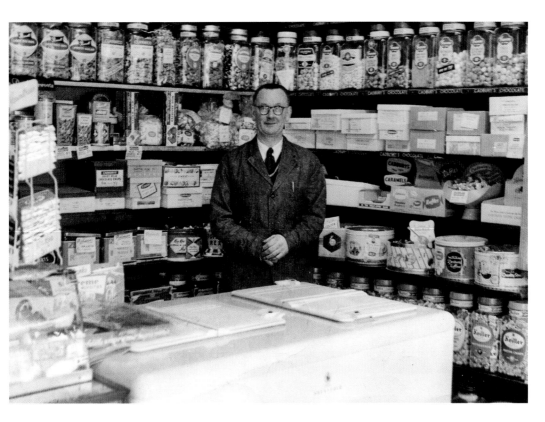

The Pendrell Brothers

Seen here inside his shop is Albert Pendrell Gould, a direct descendent of the Pendrell brothers of Boscobel, whose names live on because of their selfless efforts to aid the future Charles II to escape after he fled the Battle of Worcester in 1651. The King eventually managed to reach continental Europe, and he would reward the brothers handsomely on the restoration of the monarchy.

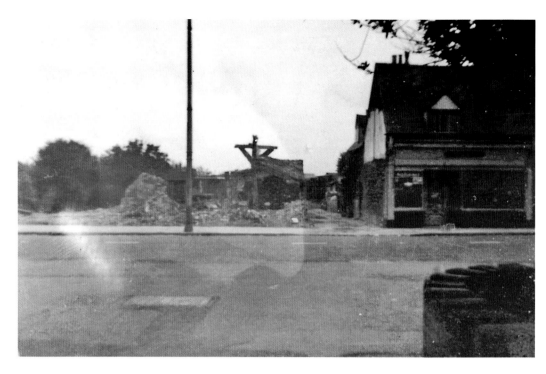

Bolebridge Street

Demolition begins in Bolebridge Street in 1956. The latest additions to the pile of rubble were once the Tallis fish and chip shop and, next door, Saunders' fruit and veg shop. Today the multi-screen cinema is on this site.

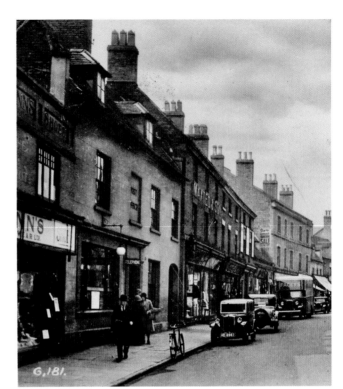

George Street
Some of the best remembered retail establishments on this street include the old post office and Dunn's shoe shop. In the distance in this photograph is a van belonging to Facey's furniture store.

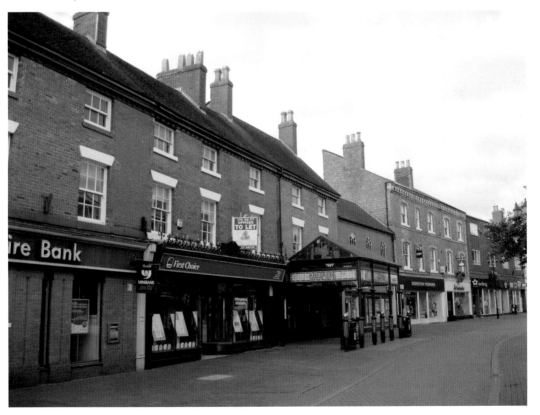

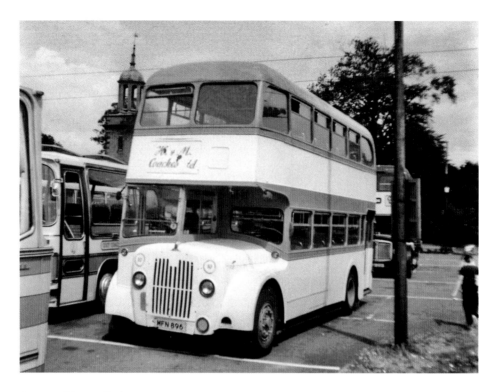

Drayton Manor Park
One of many double-deckers that brought early revellers to Drayton Manor Park. In those days, seatbelts, tachographs and even speed limiters were terms yet to enter the vocabulary. Yet everyone enjoyed their day out at least as much as the visitors do today, even if the rides were a little smaller.

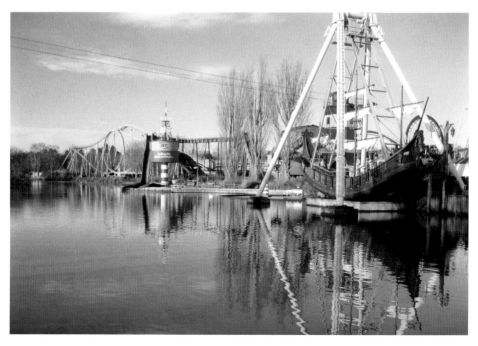

Tamworth Castle Steps
This flight of stone steps leading up to Tamworth Castle must have been trodden by thousands of feet. Labelled unsafe, the steps are being repaired. The vegetation that grew around them on the castle mound has now gone.

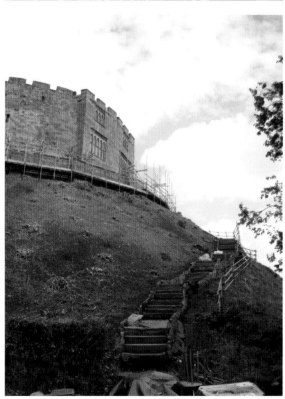

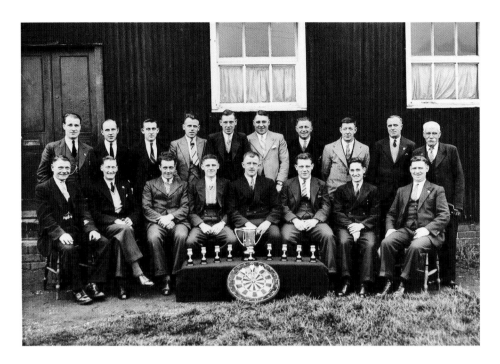

Shuttington and Alvecote

Shuttington & Alvecote Social Club CIU Darts Champions 1937/38. Do you recognise or remember Abe Sippitts, Dick Norman, Jim Walker, Walter Sheppard, Bill Bentley, Tom Harding, Dicky Arnold, Ernie Perry, Mark Hinds, Charlie Sharratt, Tom Tunnicliffe, Walter Wood, Sid Aucott, Harry Bentley, Bery Phillips, Arthur Bentley, Bill Chester, or Charlie Cope? Today, the club still has a venue for games and meetings, seen inset. Doubtless the folk of both eras also fished in the River Anker, which is seen here after having burst its banks.

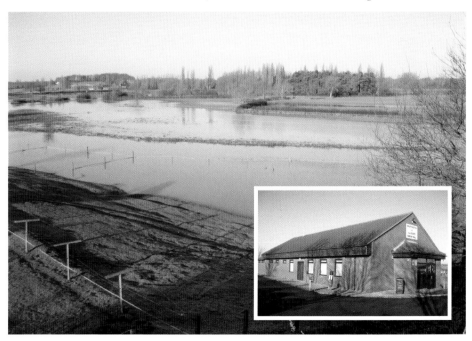

Mining

Opencast mining at Shuttington in the 1950s. The exact location is uncertain but is possibly the entrance to Laundry Lane. Today the area has a rural appearance once more.

Advertisements

Once it was the norm for advertisements to be painted on the side of a building, as here on the side of a former Glascote newsagent. Today, the *Radio Times* advertisement has disappeared, hidden behind a coat of whitewash (*below left*). Another old advertisement, for a pub, is still quite clear, as it forms part of the wall.

Hopwas Woodhouse

Hopwas Woodhouse was knocked down towards the end of the twentieth century. In its earliest days, the grounds needed much clearing and landscaping, and in this photograph three-year-old Wendy adds her weight to the work. In 2012, millions of pounds were needed to dig flood defences to prevent the Tame from encroaching upon modern housing developments.

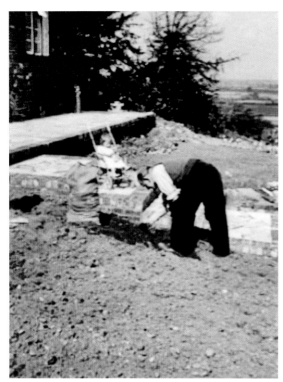

Hopwas Woodhouse
Frank Price is seen here laying the steps at Hopwas Woodhouse. The house was originally built for the Marquiss of donegall as a hunting lodge. The Price family lived there in the 1950s.

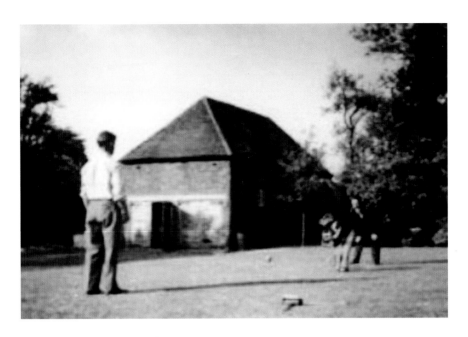

Croquet at Hopwas Woodhouse
Another image of Hopwas Woodhouse. It required a well-laid lawn for croquet...

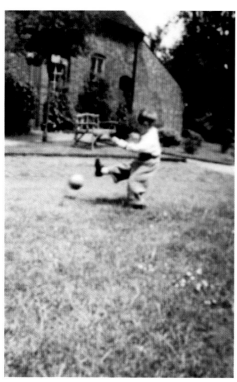

Chequers Inn
...but it was also well-suited to the budding footballer. He may have grown up to enjoy a drink at this local pub, though he probably knew it by its previous name of the Chequers Inn.

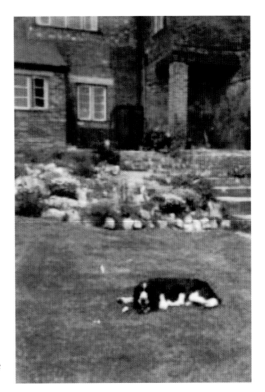

Hopwas Woodhouse
The scullery and the dining room seen from the garden of Hopwas Woodhouse. The dog and its owner may well have walked alongside the banks of the nearby River Tame.

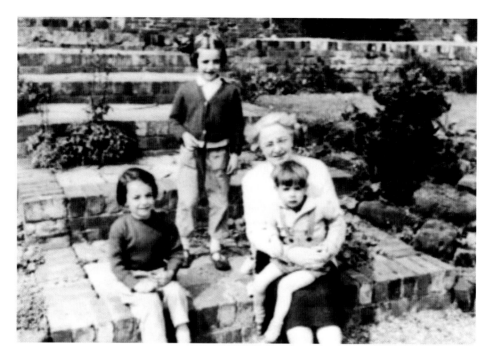

Hopwas Woodhouse

The steps laid by Frank Price double as seats for his wife and their three grandchildren in this image. The Woodhouse was recently demolished, and the area is now characterised by more modern buildings.

Wigginton Park
A view of Wigginton Park
from the entrance lodge at
what was then Copes Drive.
The Wigginton estate was
created by the Clarke family in
the early nineteenth century.

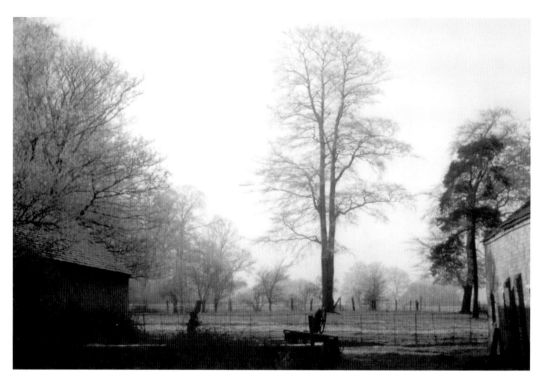

Wigginton Park
The cow sheds at Wigginton Park during the 1950s, when it was occupied by the Mansell family.

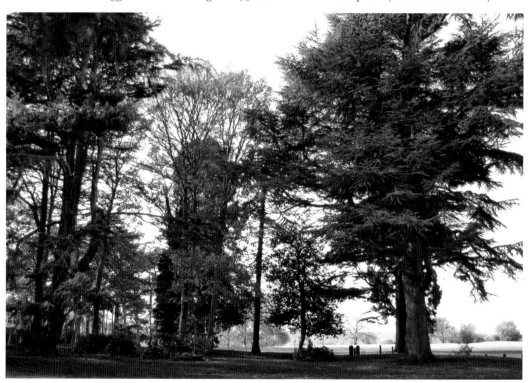

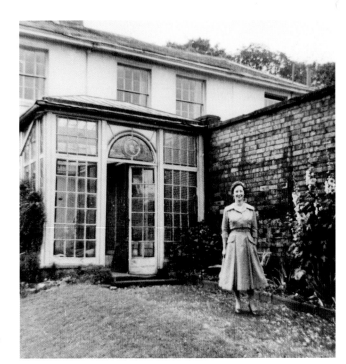

Wigginton Park
Mrs Mansell is seen here outside the glass conservatory at Wigginton Park.

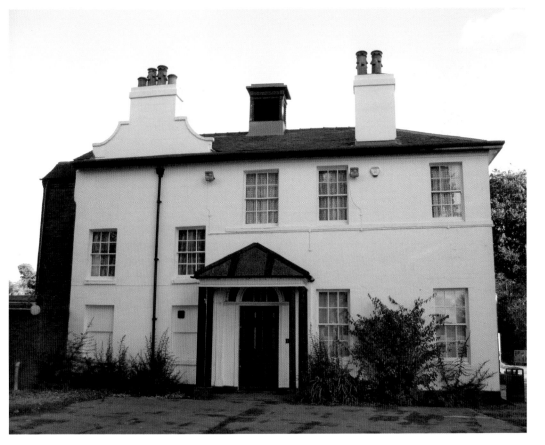

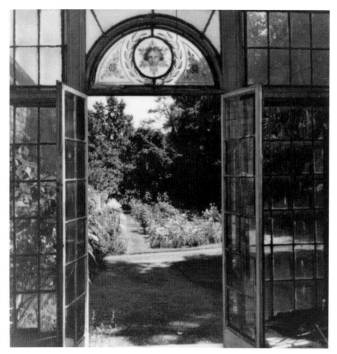

Wigginton Park
The view from Wigginton Park's conservatory, which was declared unsafe and demolished in 1959.

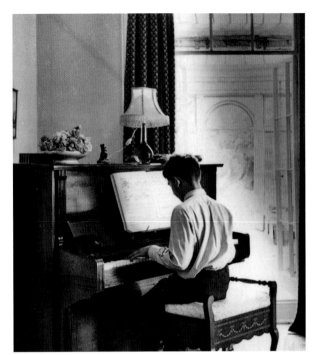

Robert Mansell
Robert Mansell plays the piano in
the conservatory at Wigginton Park.

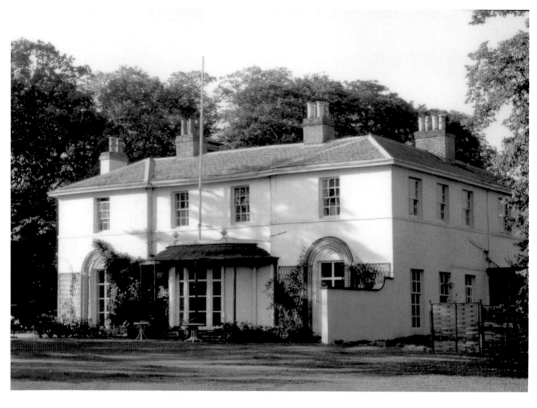

Wigginton Hall
The rear of Wigginton Hall after 1959, with no sign of the glass conservatory.

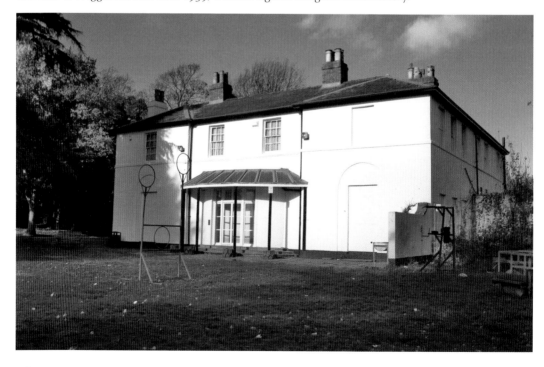

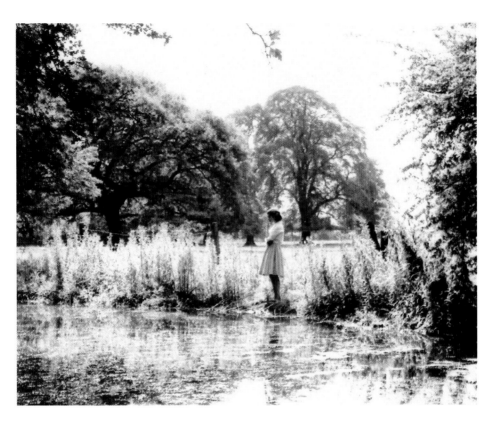

Lake
Miss Mansell, Robert's sister, enjoys the serenity of the lake at Wigginton Park.

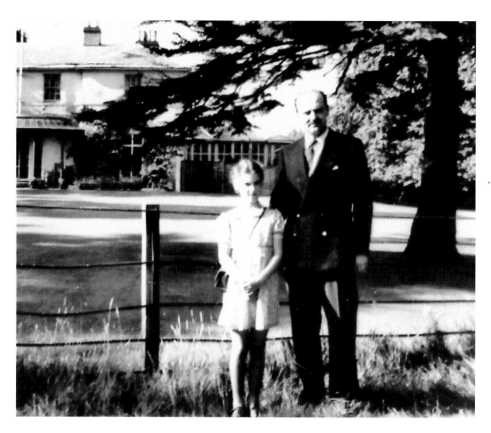

Wigginton Hall Garden

Despite the fence, seen here behind Mr Mansell and his daughter, the family often awoke to find the cows in the garden.

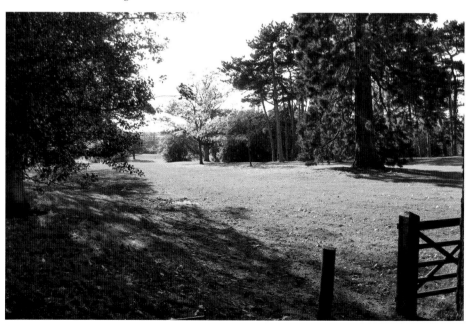

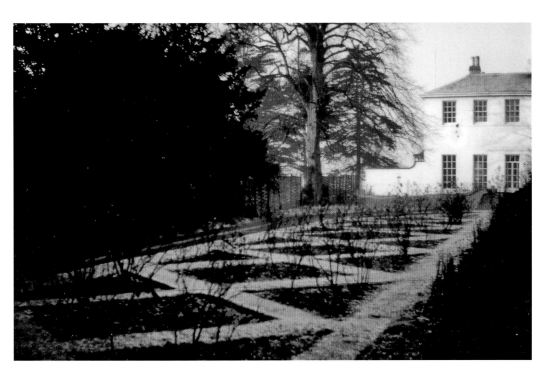

Wigginton Hall Garden

Robert Mansell was charged with keeping the intricate patterns of grass between the rose beds mown and neatly edged. Here the roses are absent as it is winter...

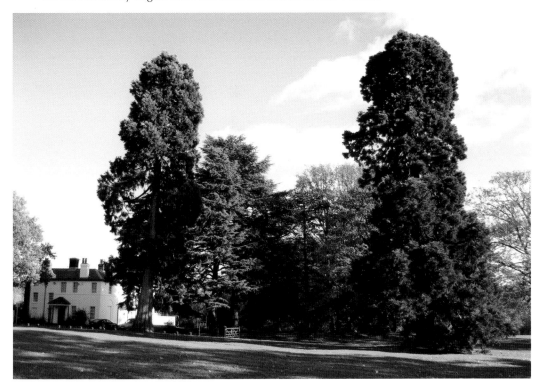

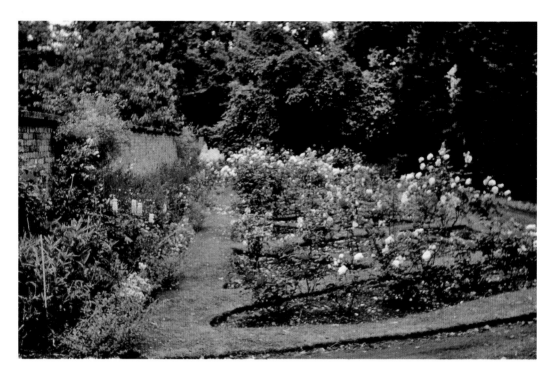

Roses

...but in the summer the roses in full bloom were a sight to behold. The modern photograph is taken in one of the nearby suburban streets that surround the park today.

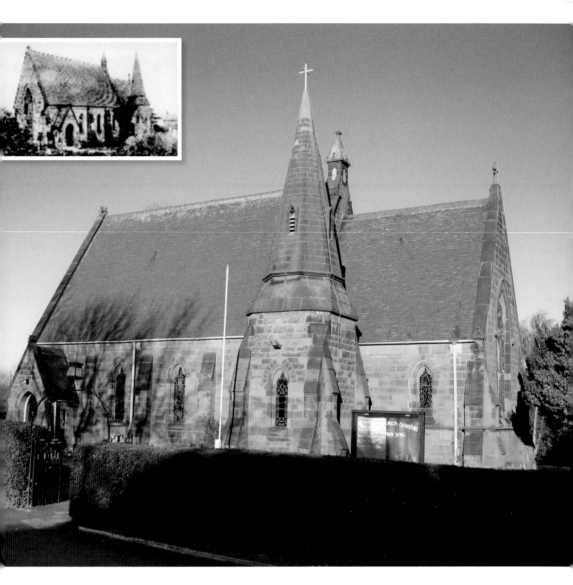

Dosthill Church

Dosthill's church is of Victorian origins, but it was built to replace the tiny, ancient Norman chapel, Dosthill's oldest building, which still stands in the church grounds.

Dosthill High Street
Dosthill High Street has changed little over the last four or five decades...

Dosthill High Street
...however, today it has more trees.

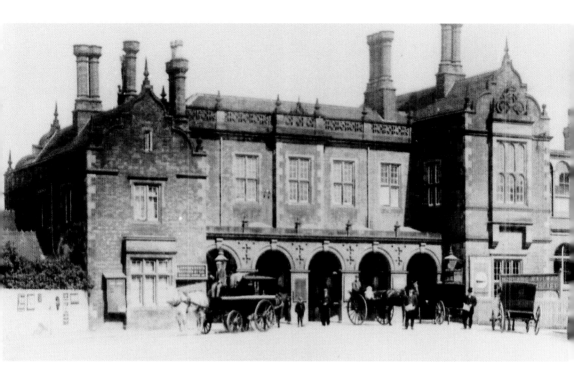

Railway Station

There is nothing left of Tamworth's Victorian railway station today. A newer building, dating from 1961 has taken its place today.

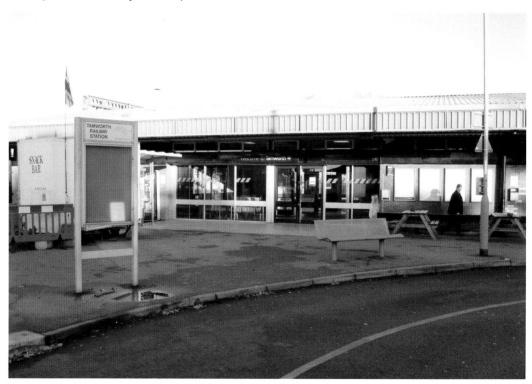

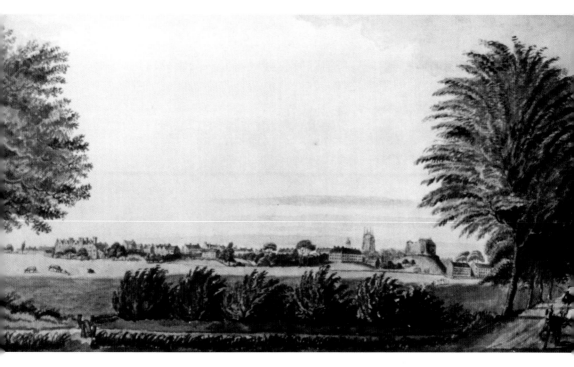

Tamworth in 1780
Stebbing Shaw's view of Tamworth in 1780 is a little out of proportion when compared with the modern view, but still recgnisable.

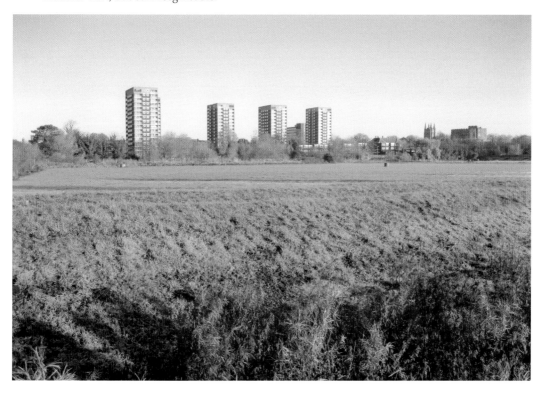

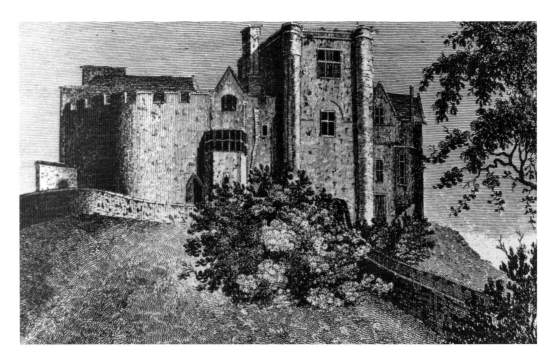

Tamworth Castle

Tamworth Castle is one of the best-preserved motte-and-bailey castles in England. It is pictured here in the 1780s, when it was home to the Earl of Leicester. However, it dates back to the Norman period, and the site, overlooking the Tame, has been fortified since Anglo Saxon times.

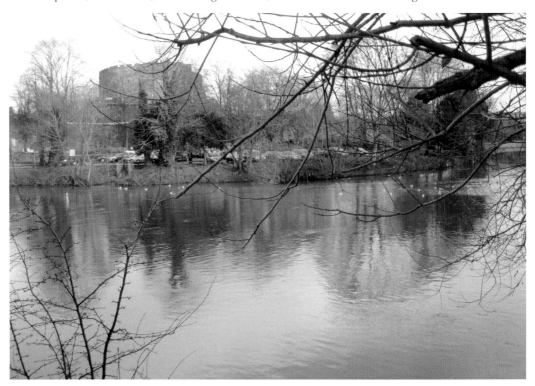

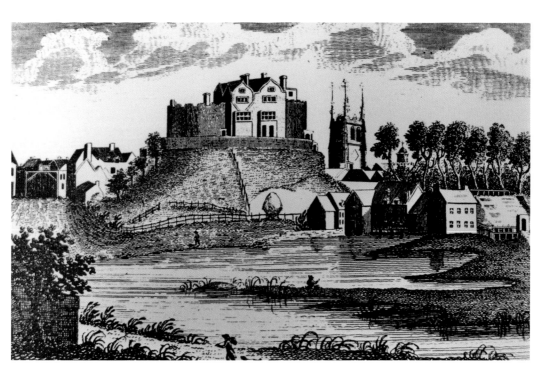

Rivers Tame and Anker
Tamworth in the 1780s, showing the confluence of the River Tame, which gave the town its name, with the River Anker, named for an anchorite or hermit who once lived along its banks.

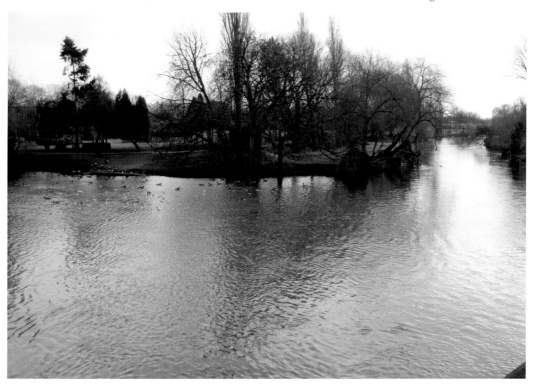

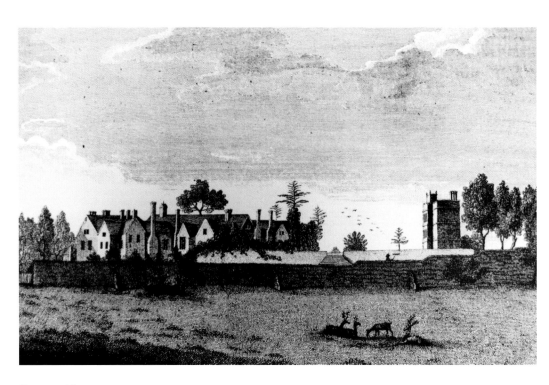

Drayton Manor
Stebbing Shaw's view of Drayton Manor in 1791. The deer in the foreground occupy a deer park, which is still remembered in the road names around Fazeley.

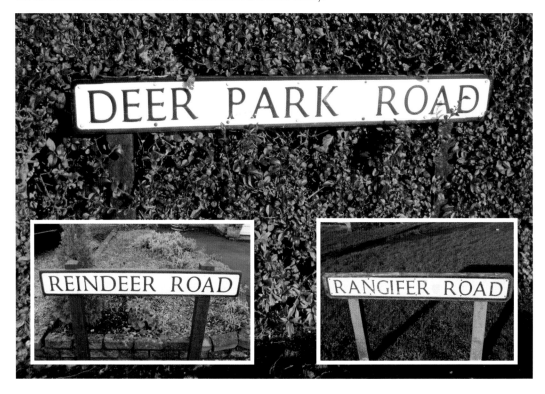

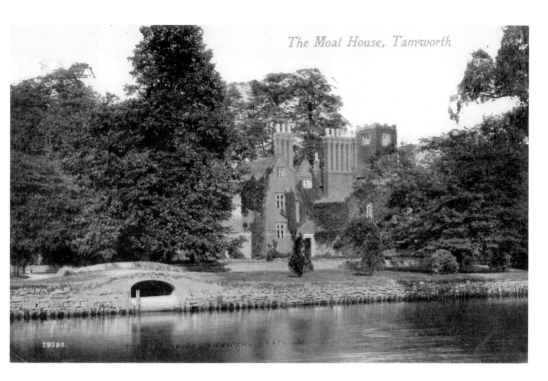

The Moat House, Tamworth

Moat House

While the building has hardly changed at all, the entrance through the grounds to the house is now very different.

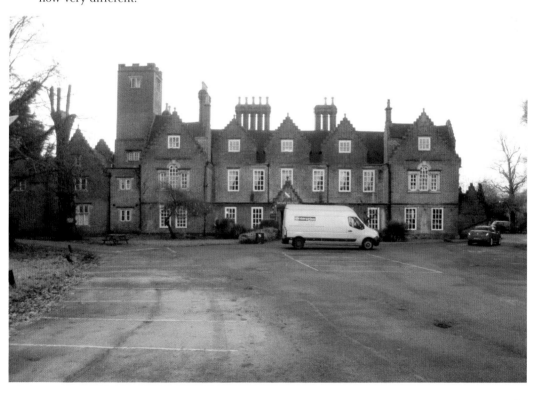

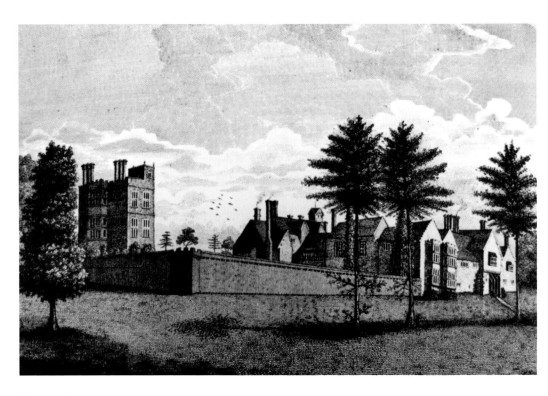

Drayton Manor
This time the old view of Drayton Manor is from the south-west. The modern park incorporates some of the original features.

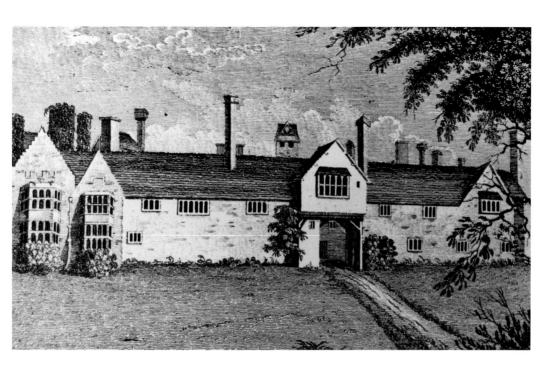

Drayton Bassett

Drayton Bassett in 1791 and 2012. Archaeologists uncovered evidence of a much earlier and very substantial building here duringduring preparatory work for a twentieth-vcentury housing development. it is thought that it was the medieval predecessor of Drayton Manor.

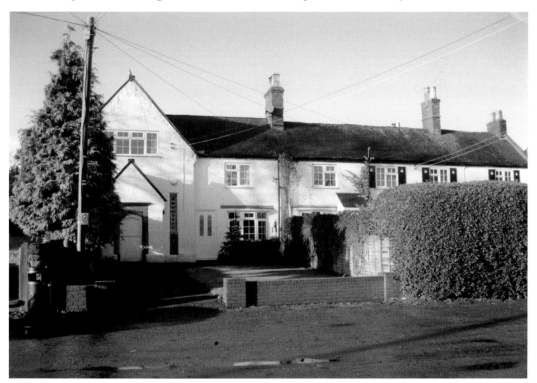

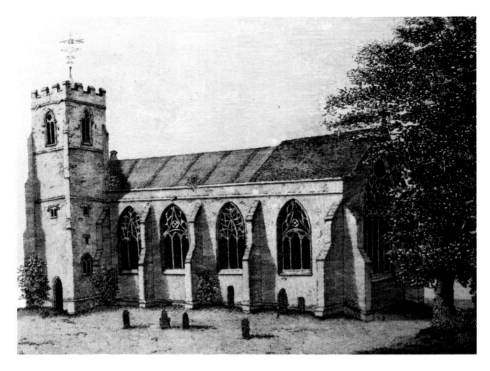

Drayton Bassett Church

The church at Drayton Bassett is dedicated to St Peter and is home to the tombs of several generations of the Peel family, the most famous being Sir Robert Peel, prime minister and founder of the modern police force.

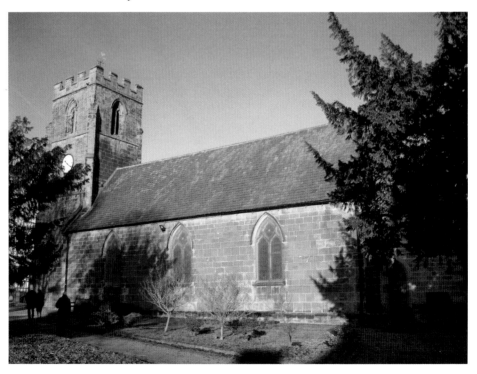

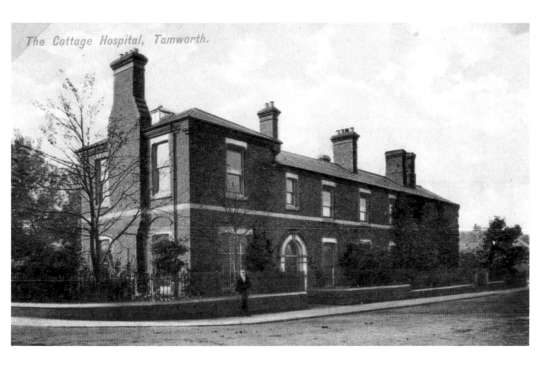

The Cottage Hospital, Tamworth.

Former Hospital
Tamworth's hospital in Hospital Street is now closed. It was recently renovated to become a number of private residences.

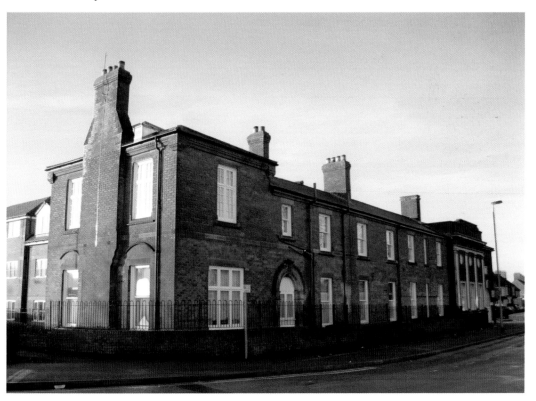

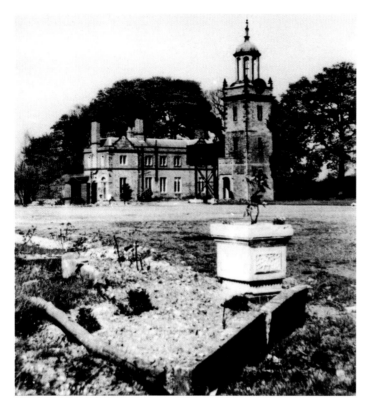

Tower
Remnants of the original estate at Drayton Manor in its earliest days as a theme park; the tower is still a dominant feature.

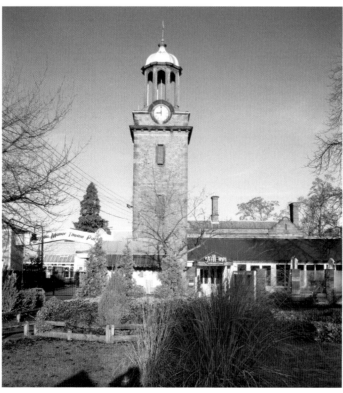

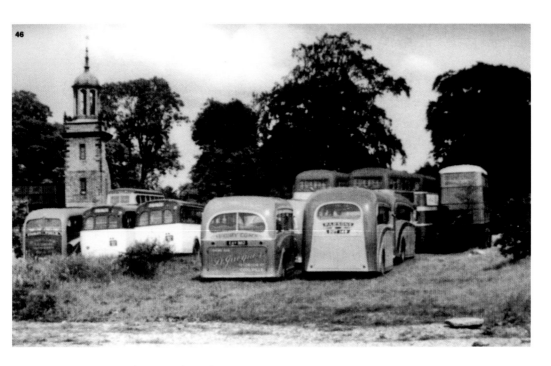

From Manor to Theme Park, 1960s

This early 1960s image shows a few of the coaches that brought the first visitors to Drayton Manor's new theme park. In the modern picture we see a twenty-first-century ride and a much older clock tower on the skyline.

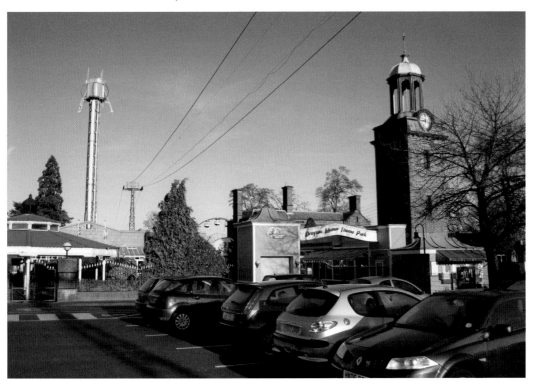

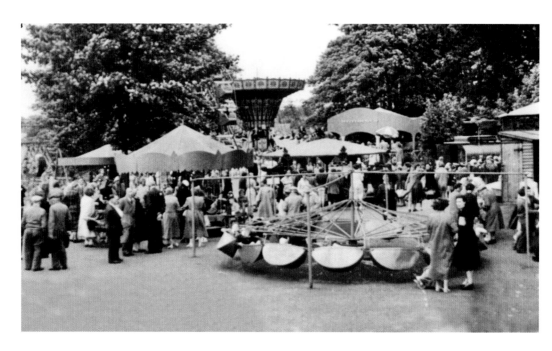

Drayton Manor Theme Park
The rides have changed considerably over the last fifty years...

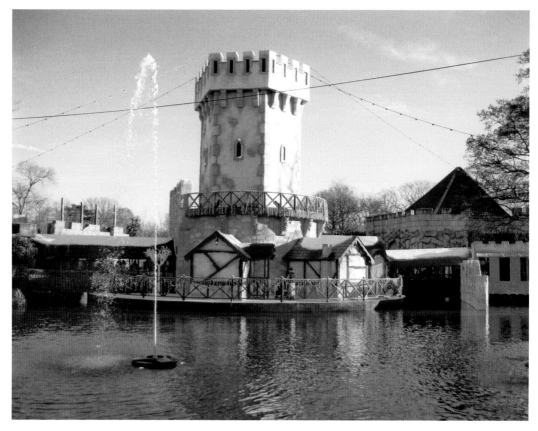

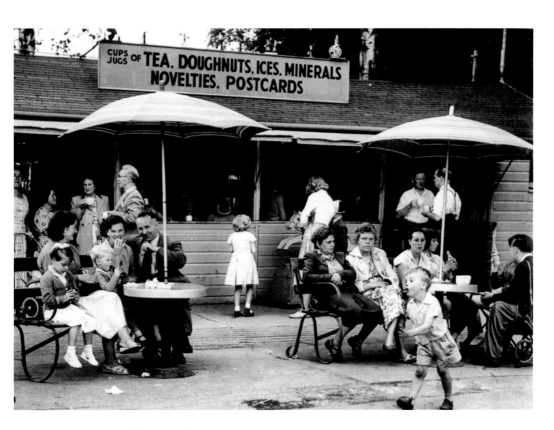

Drayton Manor Theme Park
...but thankfully, tea and ice cream are still on the menu, as are doughnuts – even if they are now spelled 'donuts'!

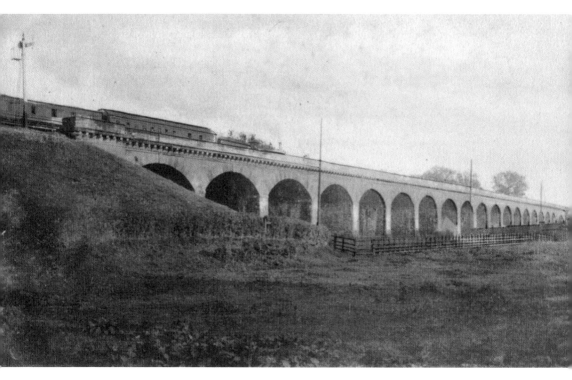

Viaduct
This is one of the few images where all nineteen arches of the railway viaduct can be seen. It is paired with a view of the viaduct crossing the River Anker today.

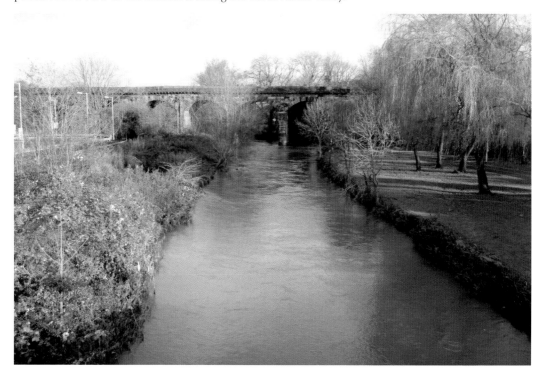

Meadow House

Meadow House, Kettlebrook, was home to Bennett's taxis when this photograph was taken. Shortly afterwards the house was demolished, and the football ground now stands on this site.

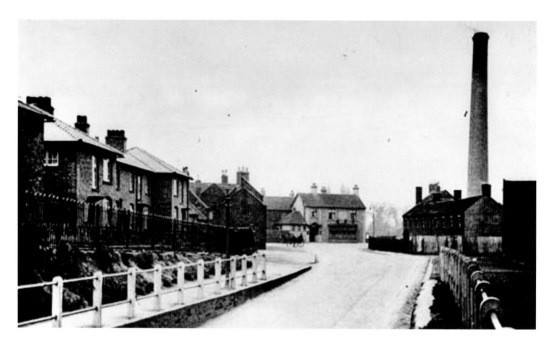

Fisher's Paper Mill

Wilnecote Lane, Kettlebrook, with Fisher's paper mill marked by the large chimney and Park Inn directly ahead. The modern view is exactly the same except for the A5 bypass, while the inset image shows the other side of the railway bridge, virtually unchanged.

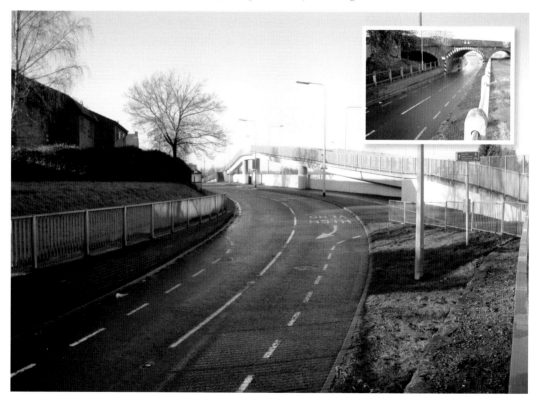

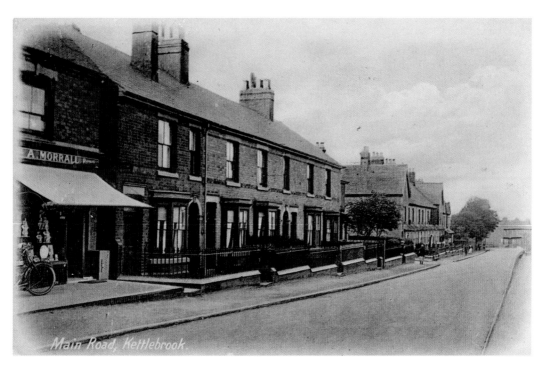

Kettlebrook Road
The social club is out of sight, as it lies back from the line of the other buildings.

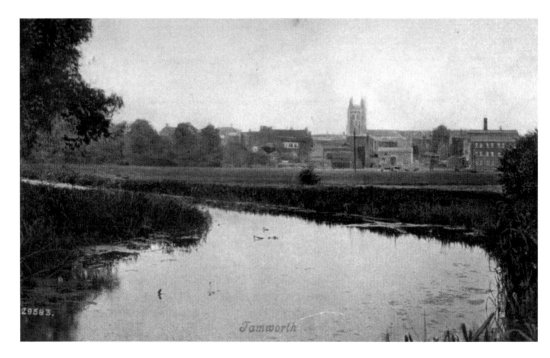

Tameside

A view from Kettlebrook Road towards the town, with St Editha's church in the centre. Today the Tameside Nature Reserve is home to birds we would never have associated with the town in the past, such as gulls and cormorants.

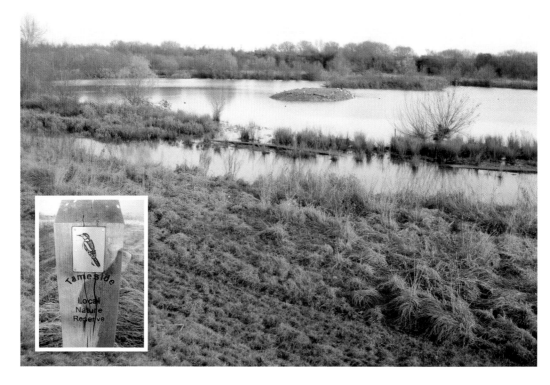

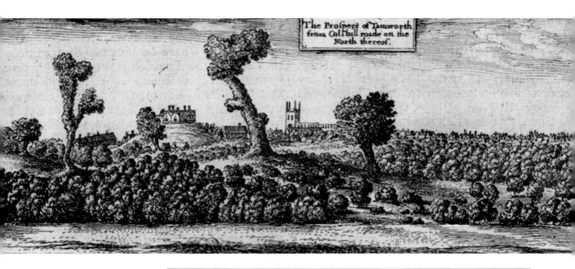

The Olympic Torch
A view of Tamworth from Colehill, as interpreted by Stebbing Shaw, above. Below, in Olympic year 2012,Tamworth marked the visit of the torch with a floral construction.

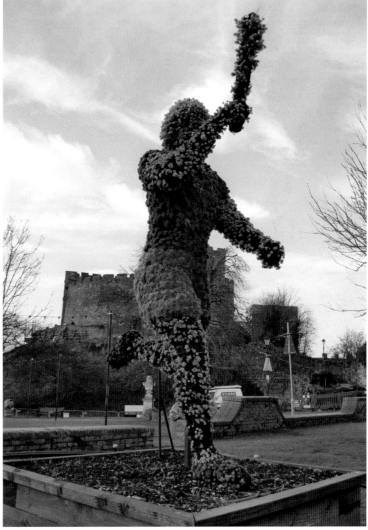

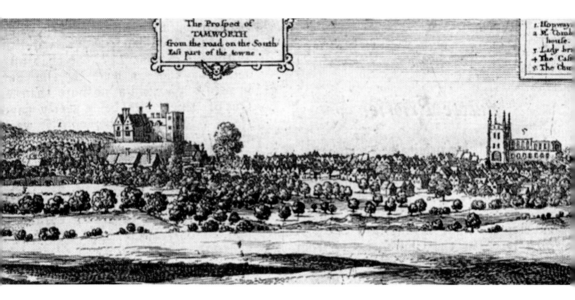

The Profped of
TAMWORTH
from the road on the South
last part of the towne.

1. Hopway:
2. M. Tomb
house.
3. Lady bri
4. The Cas
5. The Chu

South and North

Above, another Stebbing Shaw impression of Tamworth, this time from the south. Below is an autumnal view of the River Tame as it flows north towards the castle.

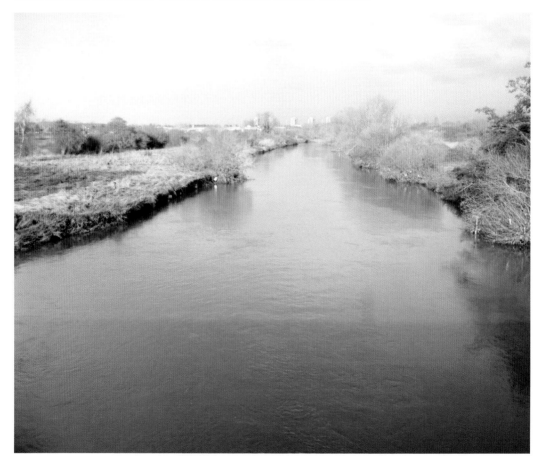

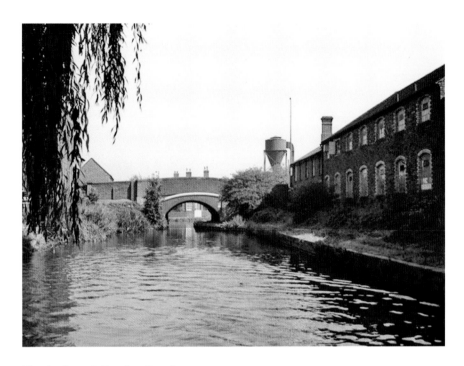

Birmingham & Fazeley Canal

The Fazeley Junction on the canal near Tamworth. These two pictures show roughly the same view, though they were taken from slightly different vantage points. The modern image was taken from Tolsons Footbridge and shows the old mill as it looks today.

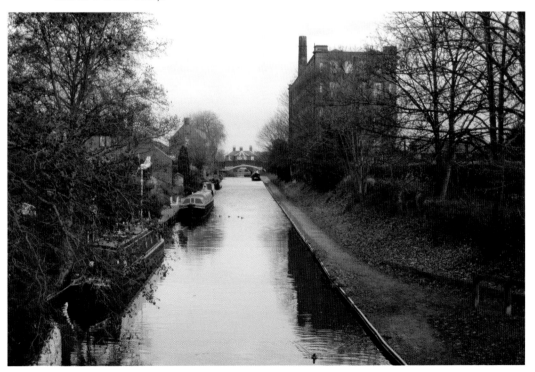

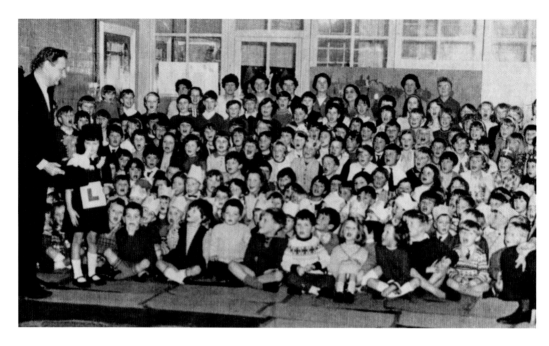

Magic!

A charming photograph of a magician entertaining the young pupils at Amington County Primary School; many of them would recognise this section of the Coventry Canal (*below*) as it passes through Amington.

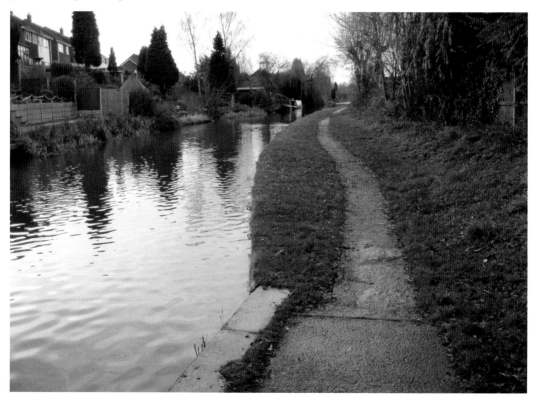

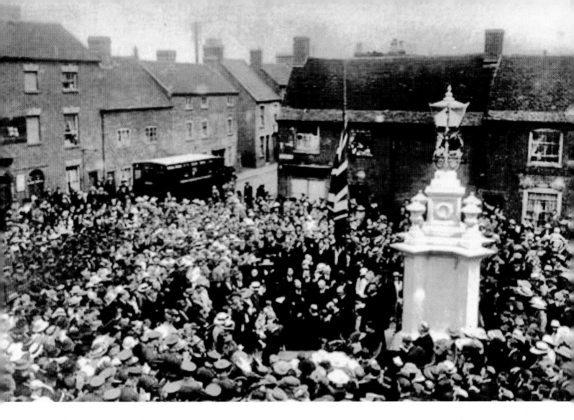

Fazeley Square and Junction House

The unveiling of the war memorial in Fazeley Square in 1925. Below, the Junction House is aptly named; it marks where the Coventry Canal meets the traffic from Birmingham, as indicated by the signpost. Together they represent the major traffic junctions of Fazeley, by road and by boat.

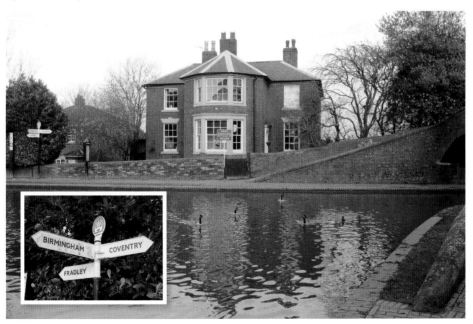

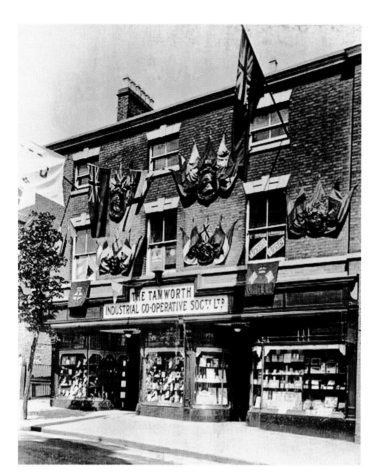

**Co-operative
& Market Street**
The Co-operative retail
outlet in Colehill is
decorated in celebratory
flags, possibly to celebrate
VE day in 1945. An
old Second World War
pillbox still guards over
the Coventry Canal and
the River Tame, below.

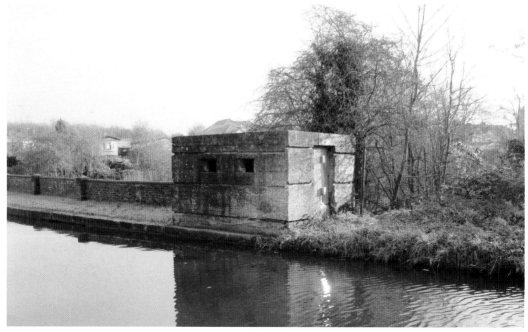

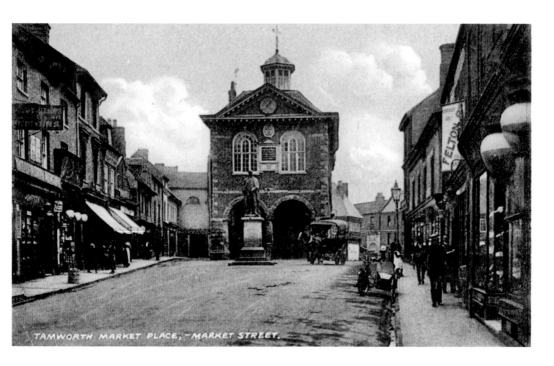

TAMWORTH MARKET PLACE, —MARKET STREET.

Market Street and the River Tame

Above, a view of Market Street; the market is conspicuous by its absence. Below, the canal is such an important part of Tamworth's history. Here it is carried over the river by the aqueduct. The arches make navigation of the River Tame by anything larger than a canoe quite impossible. Once goods may have been brought along the canal by river, but only the canal would have brought produce to the market in the days of the old image above.

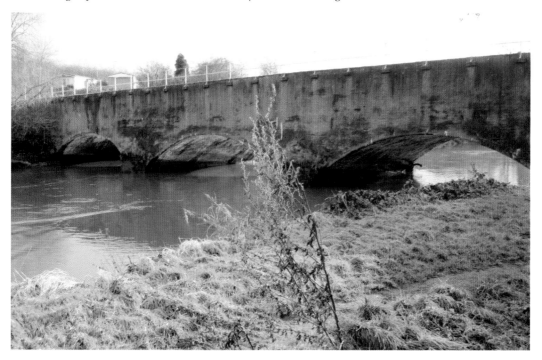

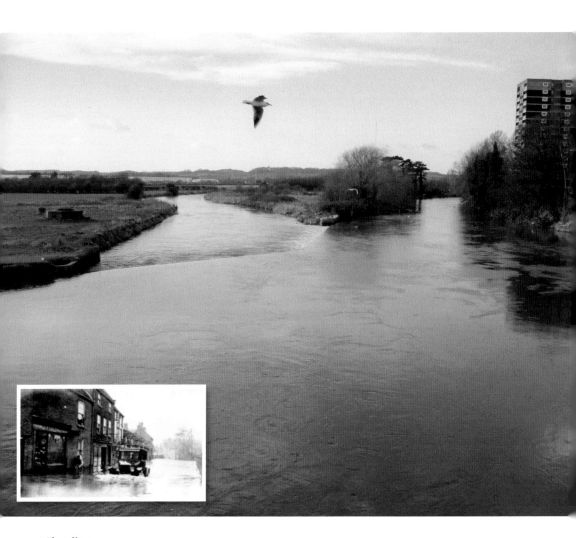

Flooding

Above, a modern view of the flood channel for the River Tame, looking downstream from Ladybridge. This and other changes have helped Tamworth to avoid floods like those seen on Bolebridge Street in May 1932, shown in the old image, inset.

Ankerside and Glascote Road

Above, a view from the castle pleasure grounds of what was to be swept away by development of the Ankerside shopping centre. Below, the former entrance to the scrapyard on Glascote Road is still marked by a wooden post that has stood here since the early twentieth century. Though no old image could be found, this well-known Tamwoth landmark had to be included in the book!

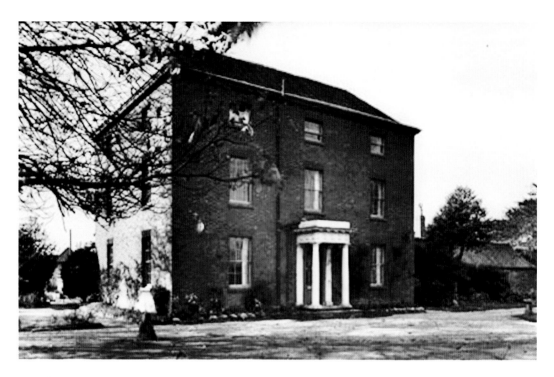

Wiggington Hotel and Glascote Boatyard

Accommodation at the Wiggington Hotel has been redeveloped as permanent residencies in the form of flats. Meanwhile, the boatyard on the canal at Glascote still produces craft – thought today they are for leisure rather than freight.

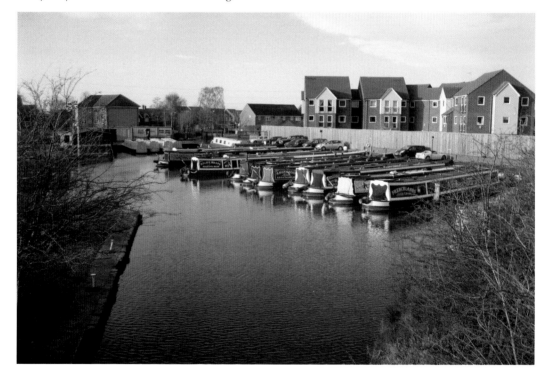

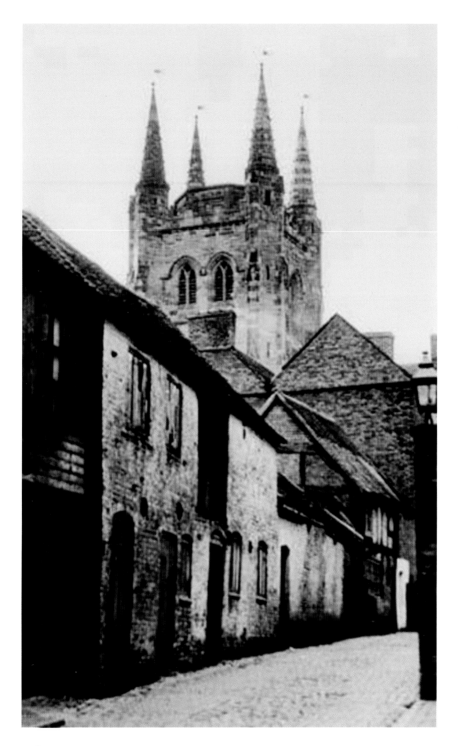

College Lane
The original College Lane, where you will now find the rears of the shops that front onto Church Square.

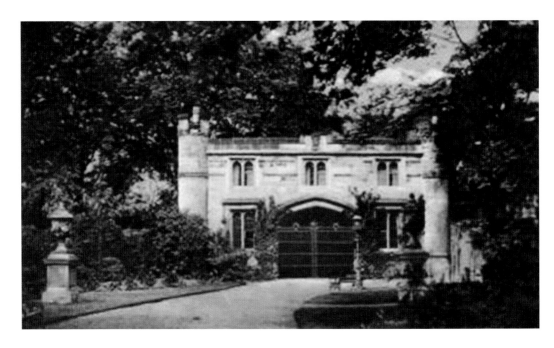

Gatekeepers and Lock-Keepers

The entrance to the castle grounds from Holloway is still recognisable today. Once, the gatekeeper would have lived above the very gate he was charged with controlling, much like the lock-keeper who lived in the solitary building on the left of the new image, still known as Lock-Keeper's Cottage.

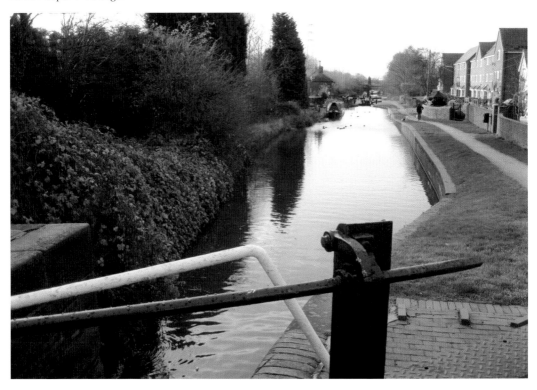

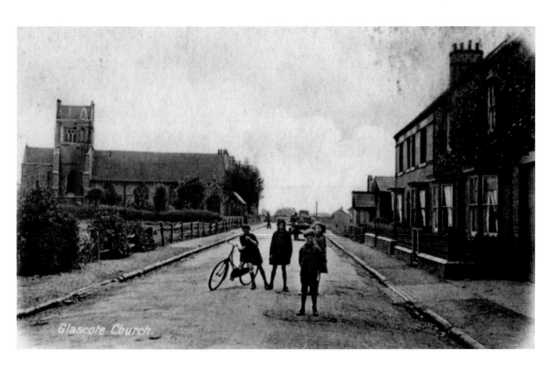

Bamford Street, Glascote

Bamford Street, Glascote, has changed little over the years, except that there a few more houses and many more vehicles.

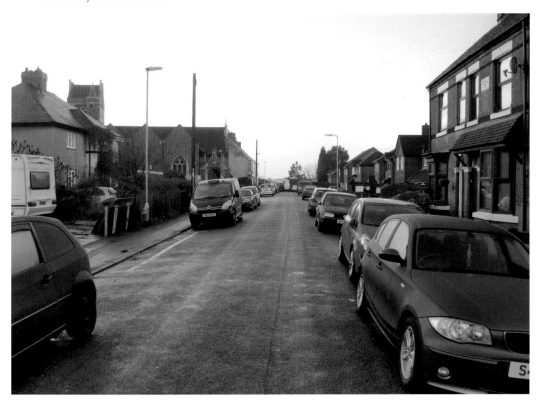

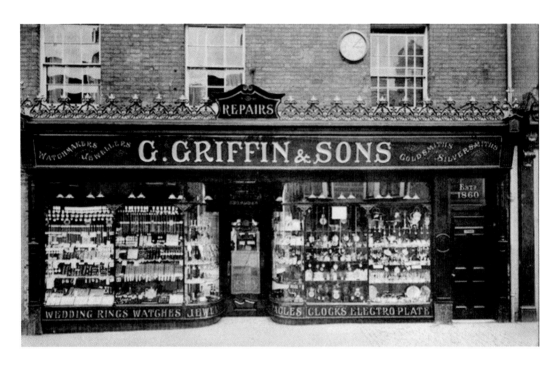

Griffin's

G. Griffin was a delight to find unchanged as Tamworth was modernised. Sadly it has not survived into the twenty-first century, aside from the mosaic, which still forms the step in the doorway.

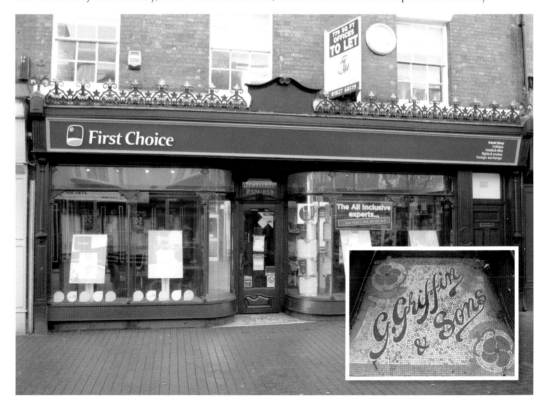

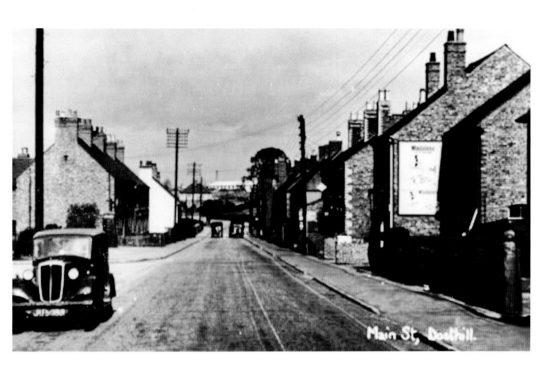

Main Street, Dosthill
Main Street, Dosthill, shortly after the Second World War. It is still recognisable today.

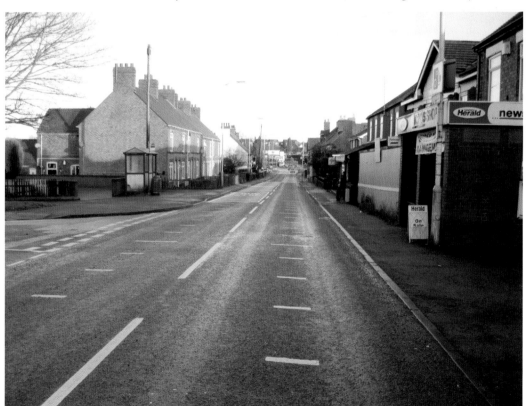

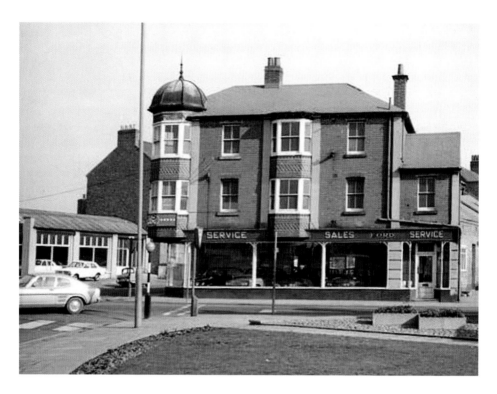

Rose Brothers' Showroom

What was formerly the car showroom of Rose Brothers has since been a pine furniture warehouse and at least four different restaurants.

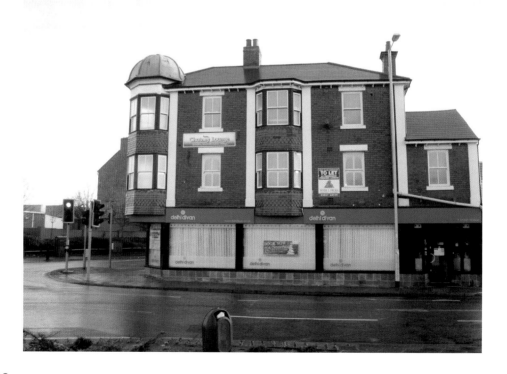

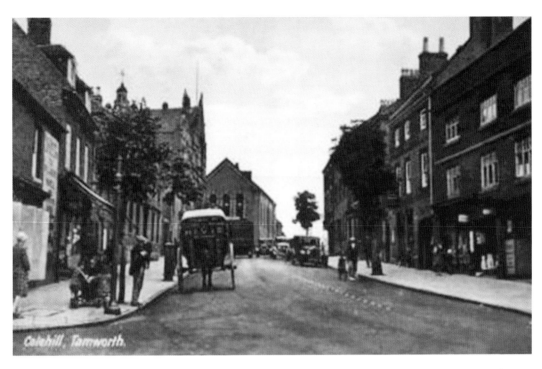

Colehill
Even without the modern view, there could be little doubt that this old view is looking up Colehill.

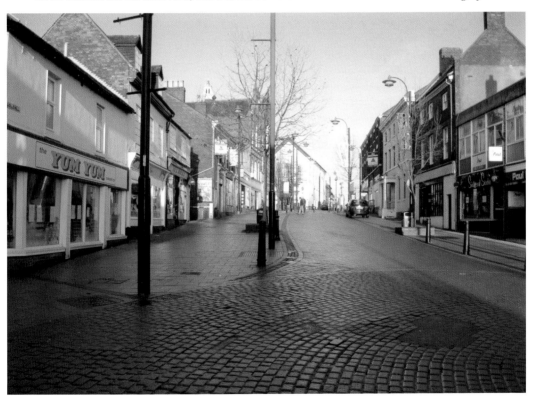

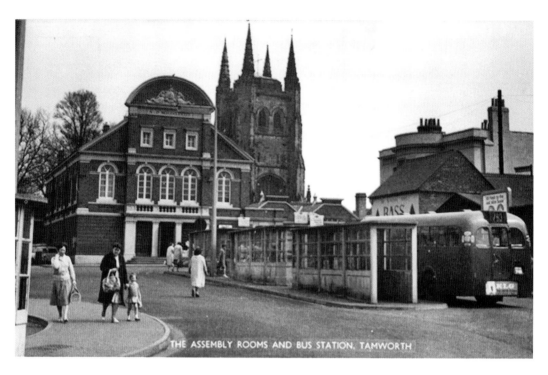

THE ASSEMBLY ROOMS AND BUS STATION, TAMWORTH

Assembly Rooms

The Assembly Rooms has hardly changed, yet the bus station in the foreground disappeared in the 1980s and is now another car park.

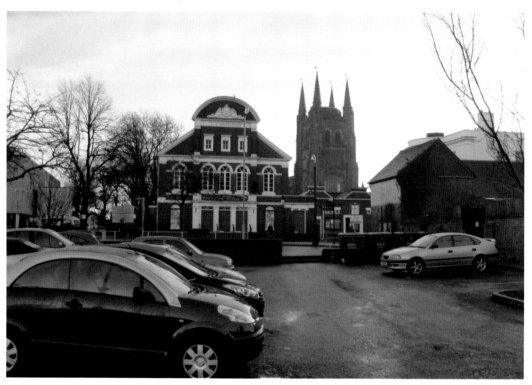

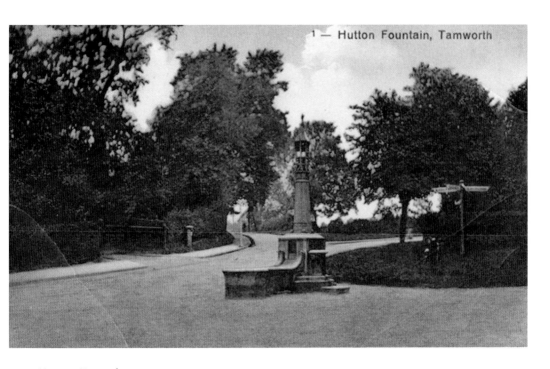

Hutton Fountain

Hutton Fountain disappeared after being hit by motorists one too many times. It was later discovered in a nearby garden.

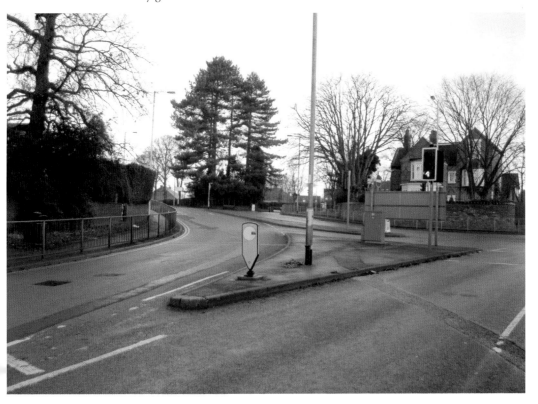

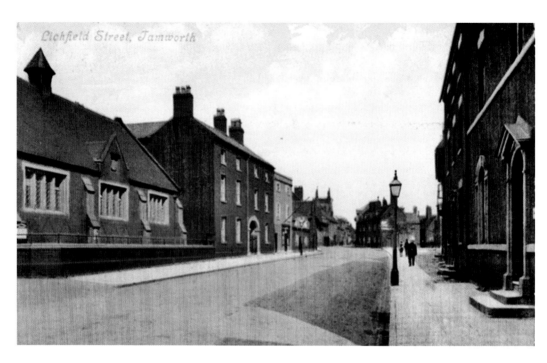

Lichfield Street

Lichfield Street looking back towards Tamworth. Not only can the buildings on the left be made out in both images, but even the steps to the doorway on the right have survived.

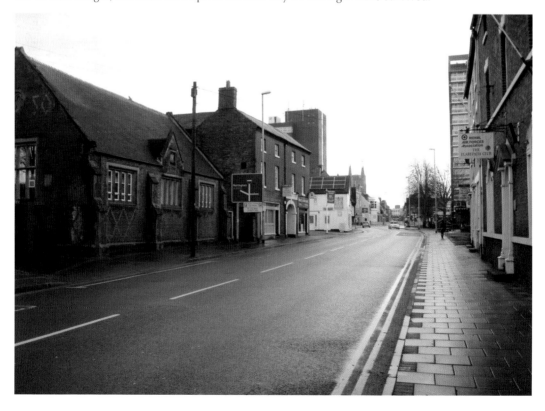

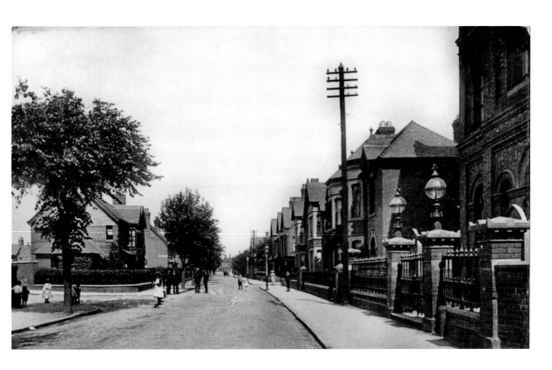

Victoria Street

Victoria Street was named following Queen Victoria's visit to the town and the estate of Robert Peel. Nearby Albert Road was named after her husband.

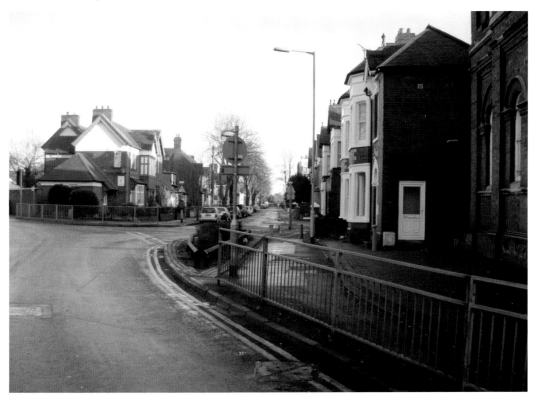

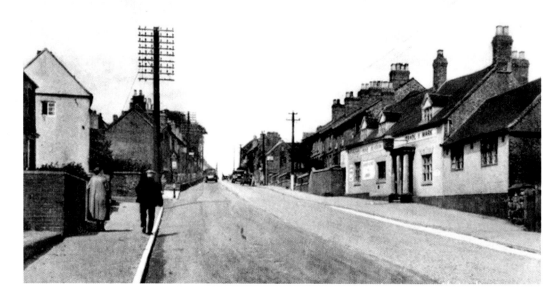

Watling Street

Some features of this early view of Watling Street at Wilnecote remain, including the Queen's Head on the right. What was then the A5, one of the major trunk roads in the country, has been downgraded to the B5404 since the opening of the bypass.